NYC

BASIC TIPS AND ETIQUETTE

NATHAN W. PYLE

BRING IT RIGHT!

NYC BASIC TIPS AND ETIQUETTE. COPYRIGHT © 2014 BY NATHAN W. PYLE. ALL RIGHTS RESERVED. PRINTED IN THE UNITED STATES OF AMERICA. NO PART OF THIS BOOK MAY BE USED OR REPRODUCED IN ANY MANNER WHATSOEVER WITHOUT WRITTEN PERMISSION EXCEPT IN THE CASE OF BRIEF QUOTATIONS EMBODIED IN CRITICAL ARTICLES AND REVIEWS. FOR INFORMATION ADDRESS HARPERCOLLINS PUBLISHERS, 10 EAST 53RD STREET, NEW YORK, NY 10022.

HARPERCOLLINS BOOKS MAY BE PURCHASED FOR EDUCATIONAL, BUSINESS, OR SALES PROMOTIONAL USE. FOR INFORMATION PLEASE E-MAIL THE SPECIAL MARKETS DEPARTMENT AT SPSALES@HARPERCOLLINS.COM.

LIBRARY OF CONGRESS CATALOGING-IN-PUBLICATION DATA HAS BEEN APPLIED FOR.

ISBN 978-0-06-230311-0

14 15 16 17 18 RRD 10 9 8 7 6 5 4 3 2

TO MY GRANDPARENTS:

CLARICE

THEODORE

PACHECO

WILLIAM

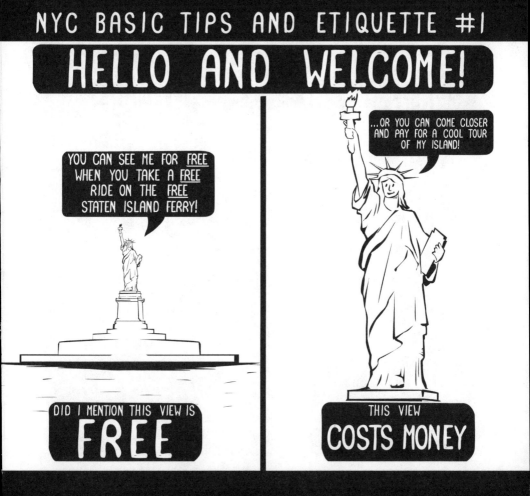

EACH PAGE OF THIS BOOK FALLS INTO ONE OF TWO CATEGORIES:

ETIQUETTE
YOU MAY NOT RANDOMLY KISS PEOPLE.

I'LL TAKE CARE OF THAT GARBAGE FOR YOU!

TIP
BEWARE THE *REAL* FURRY MONSTERS IN THE TRASH.

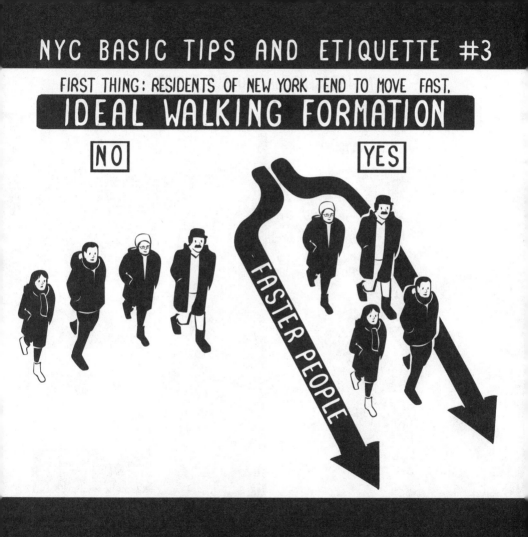

NYC BASIC TIPS AND ETIQUETTE #4

NEW YORKERS LIKE TO BUY THINGS

WITHOUT EVEN LEAVING THE SIDEWALK!

MY BEAUTIFUL HOMETOWN!

FAST FOOD

WRAPS

COFFEE

CONVENIENCE

BUS TO NYC

KETTERING, OHIO

2008!
HOME SINCE
MY BEAUTIFUL
NYC

FOOD CART

GYROS

COFFEE CART

NEWSSTAND

DAILY WIT SIGN

IF IT SAVES SECONDS, *THEY'LL DO IT*, THAT'S WHY YOU SHOULD →

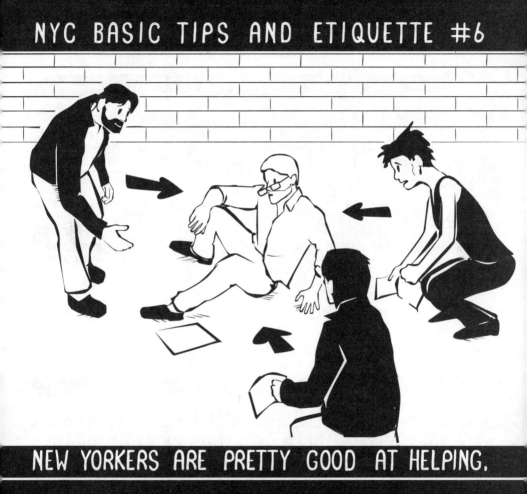

-SCRATCH THAT-

NEW YORKERS ARE *PRETTY GREAT* AT HELPING.

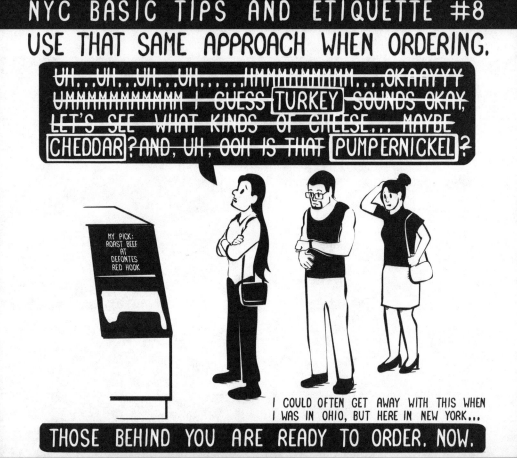

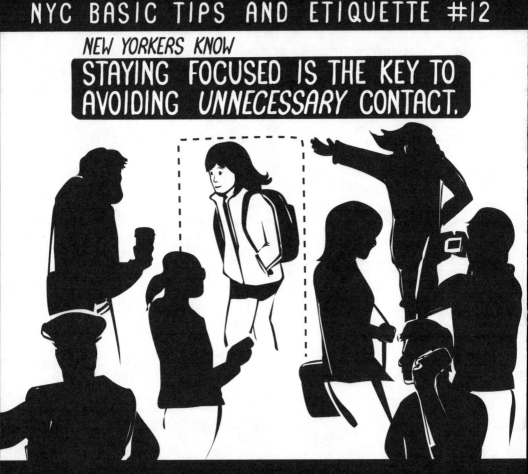

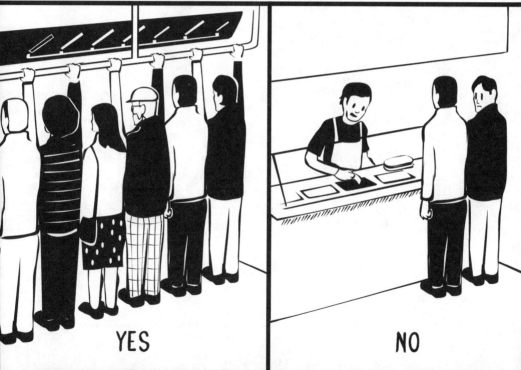

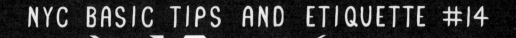

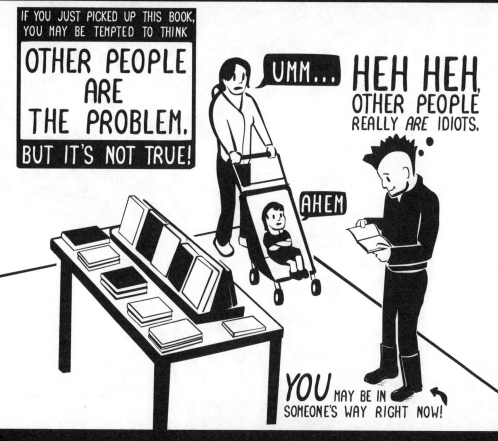

NYC BASIC TIPS AND ETIQUETTE #18

ONE $20 UMBRELLA WILL OUTLAST FOUR $5 UMBRELLAS.

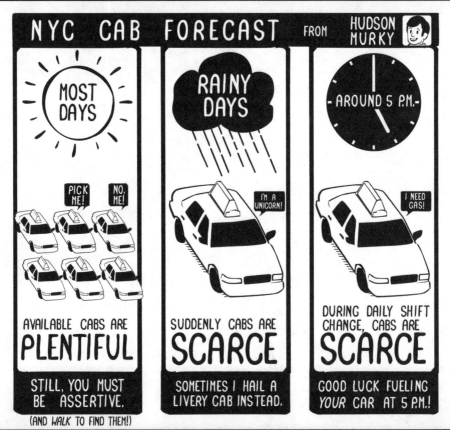

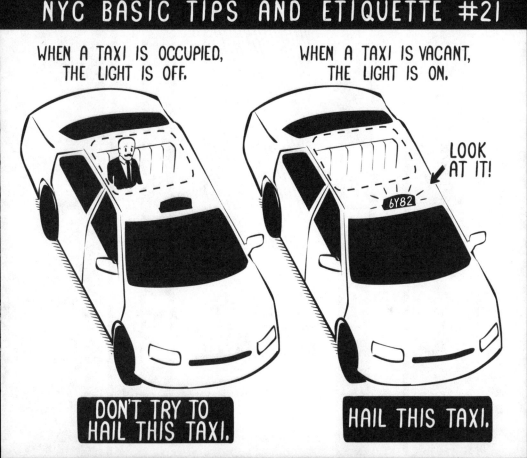

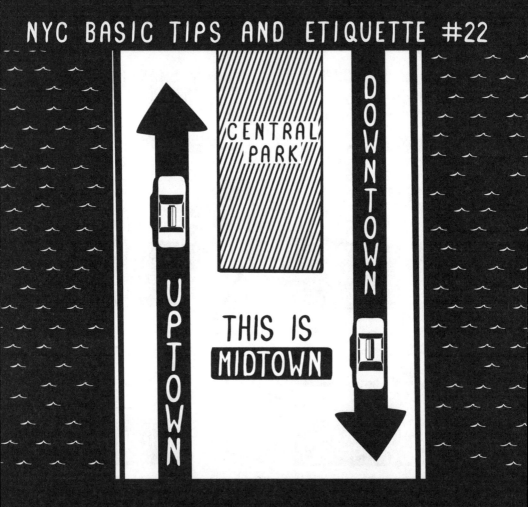

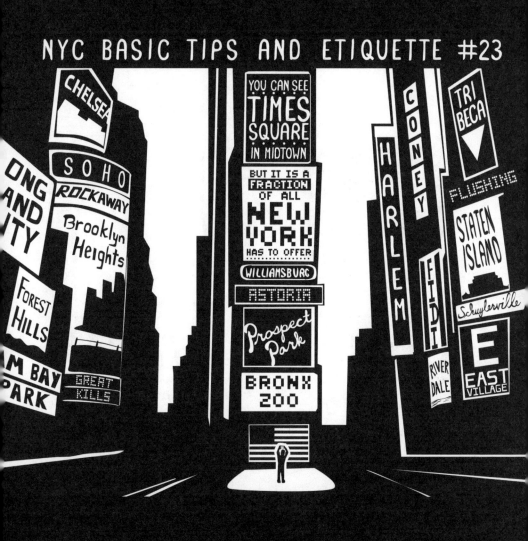

MANHATTAN
B R I D G E

MADE OF
METAL

BROOKLYN
B R I D G E

BUILT FROM
BLOCKS

← louder
borough

outer →
borough

volume

TO SEE ALL THIS, YOU'LL PROBABLY TAKE

MASS

(LARGE GROUPS OF PEOPLE)

TRANSIT

(TRYING TO GO SOMEWHERE).

MANY AWKWARD INTERACTIONS WILL TAKE PLACE IN THESE **BOXES O' PEOPLE.**

THIS TRAM GOES TO ROOSEVELT ISLAND. IT IS NEAT. ➡️

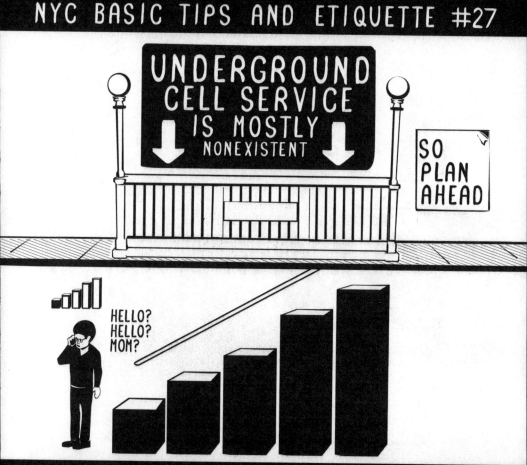

IF YOU DON'T HEAR A

CLICK

← THAT TURNSTILE'S GONNA

STICK

WHEN YOU'VE SUCCESSFULLY SWIPED YOUR CARD, YOU'LL HEAR THE TURNSTILE UNLOCK.

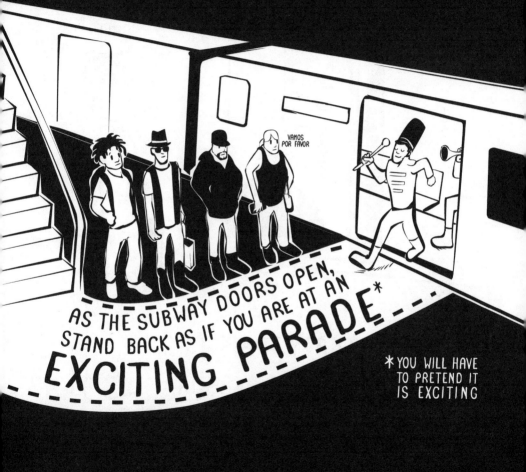

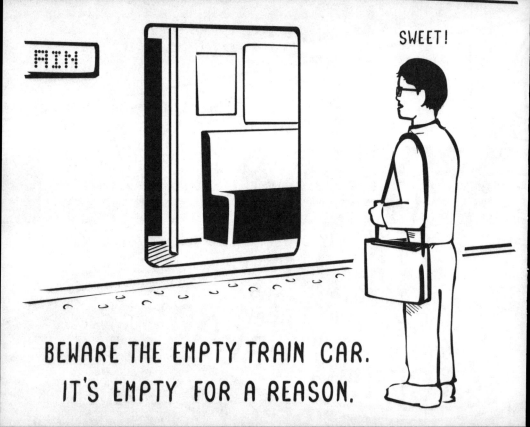

NYC BASIC TIPS AND ETIQUETTE #31

NO YES

IT DOESN'T MATTER WHO YOU ARE. PUT IT ON YOUR LAP.

NO YES

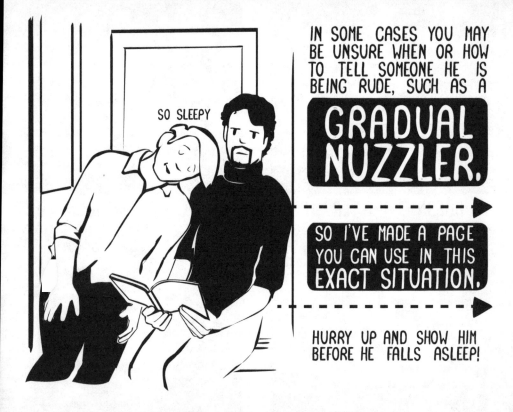

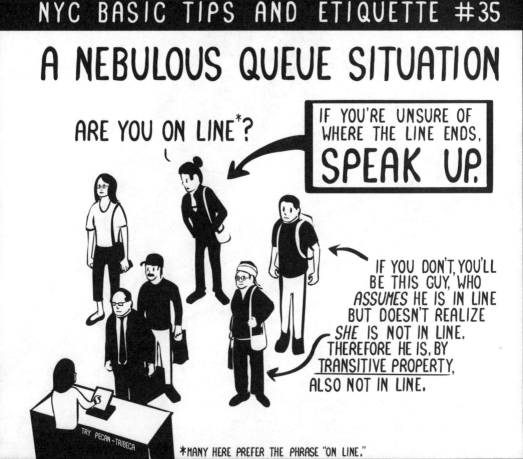

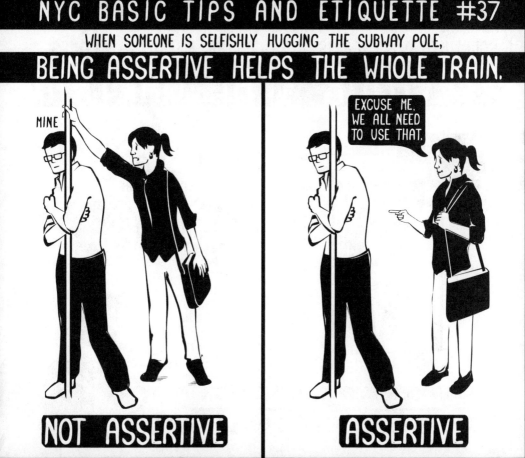

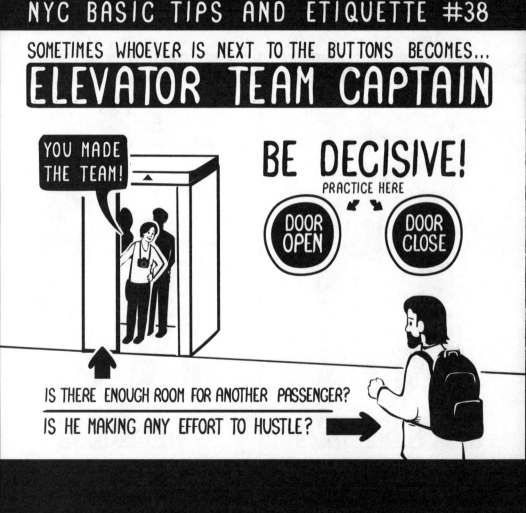

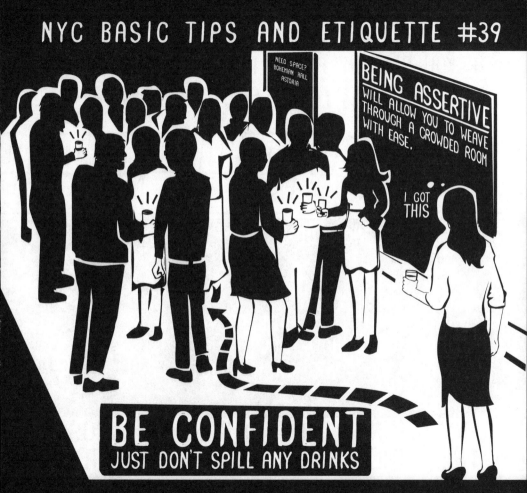

IF YOU SEE THE POLICE SETTING BARRICADES UP,

CROWDS ARE COMING.

EVENTS MAY INCLUDE:
 PROTESTS
 PARADES
 PROTEST-PARADES
 COUNTER PROTEST-PARADE PROTESTS
 HOLIDAYS YOU KNOW ABOUT
 HOLIDAYS YOU DON'T KNOW ABOUT
 BOY BANDS

COOL THINGS LIKE DRIVING OR CROSSING
THE STREET MAY SOON BE DIFFICULT!

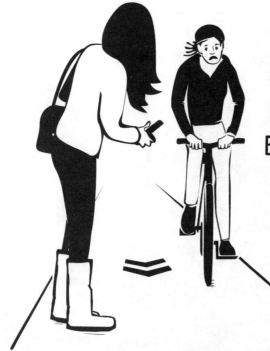

BUT IF YOU STAND
IN THE BIKE LANE,
BIKES WILL HIT YOU.

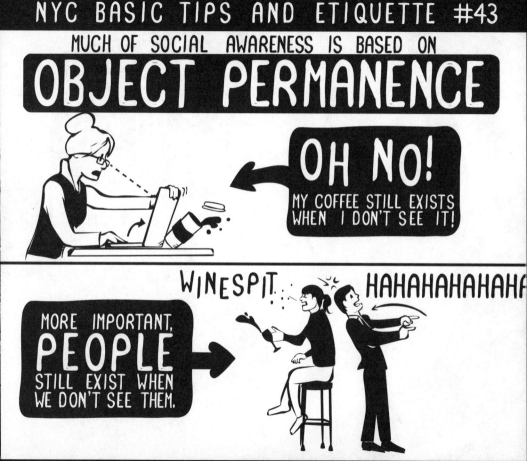

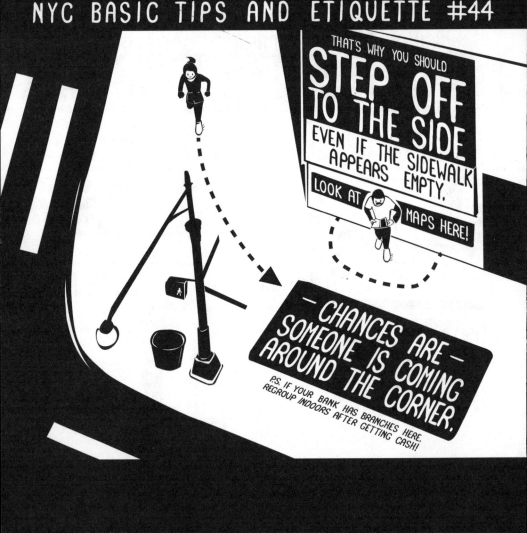

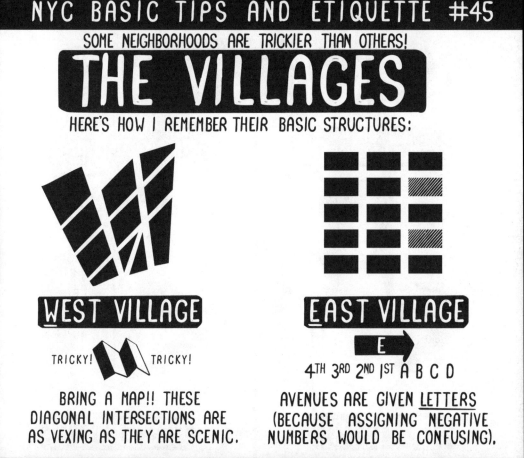

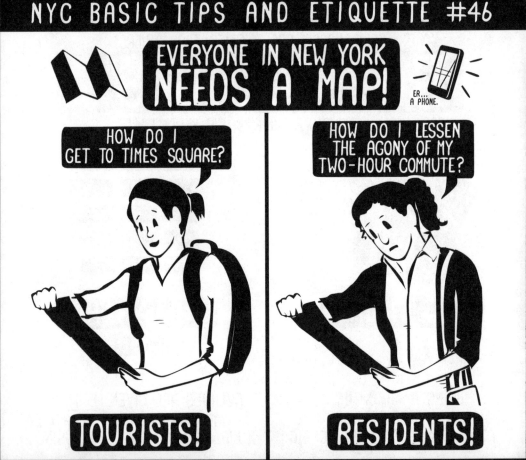

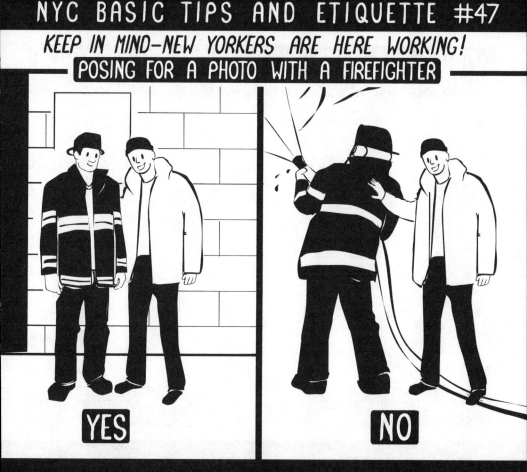

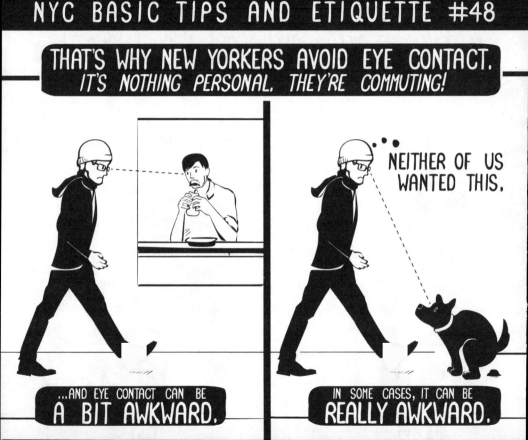

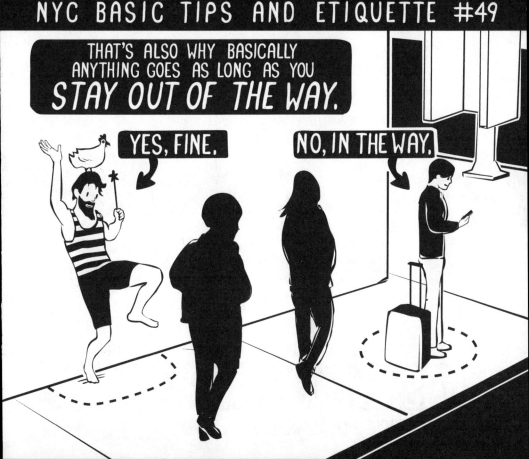

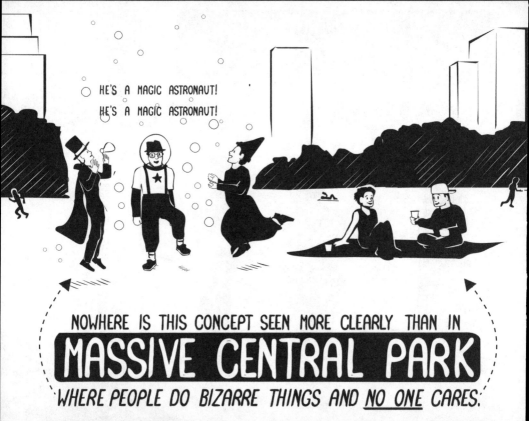

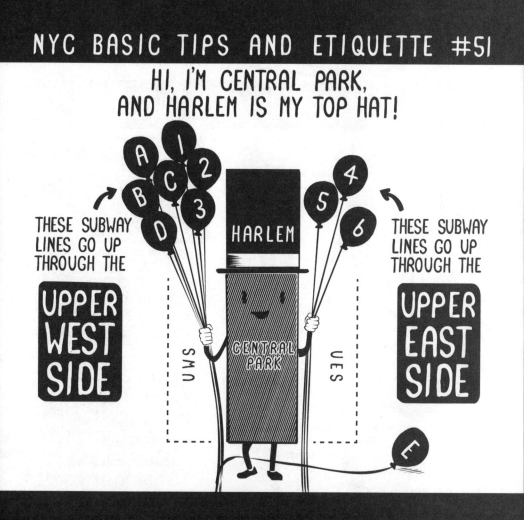

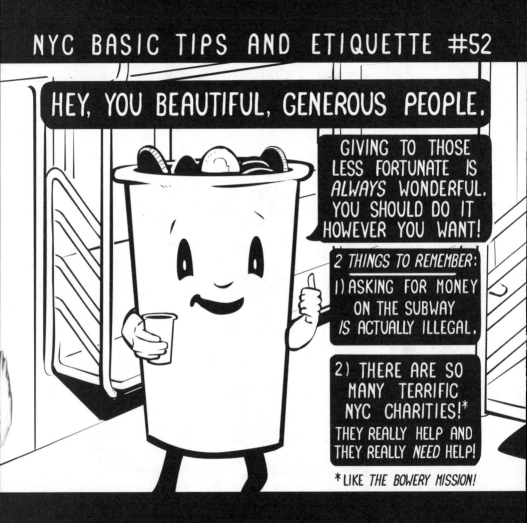

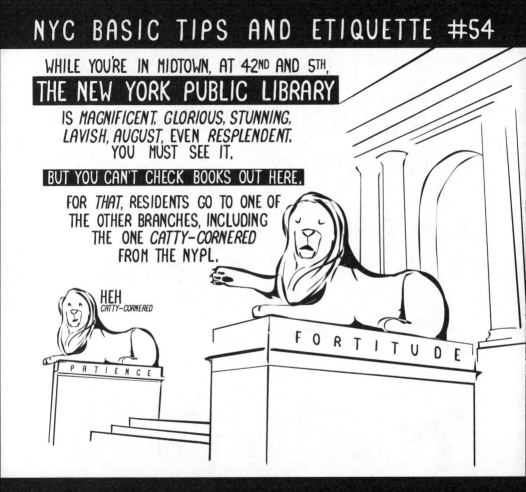

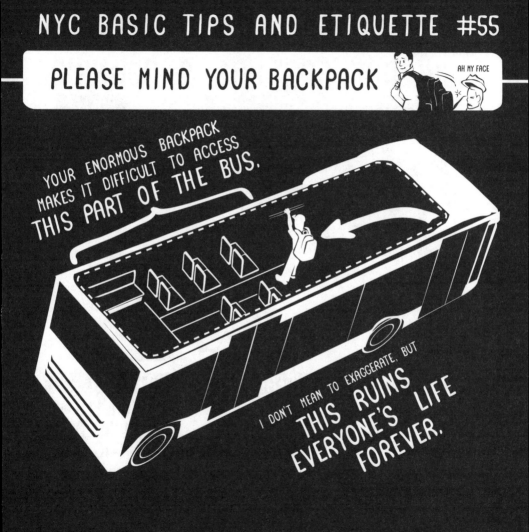

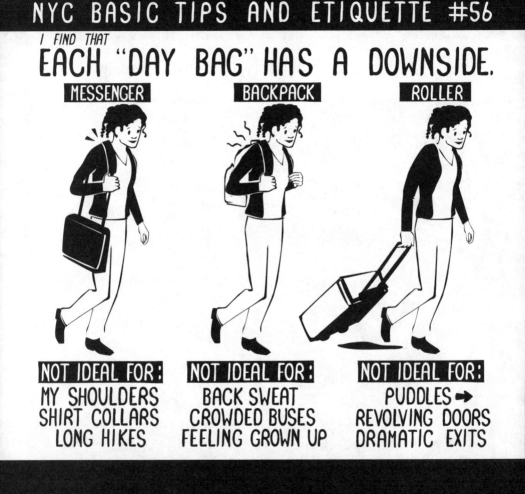

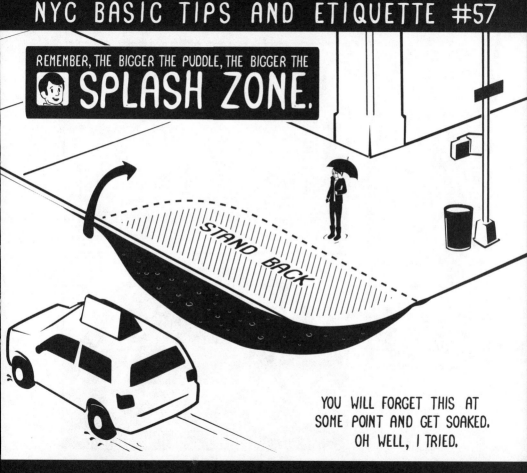

SPEAKING OF STANDING BACK,

STAND WAAAY BACK.

A BASIC RULE FOR PHOTOGRAPHING THE MANHATTAN SKYLINE:

FOR BEST RESULTS, TRY CROSSING A ~ RIVER! ~

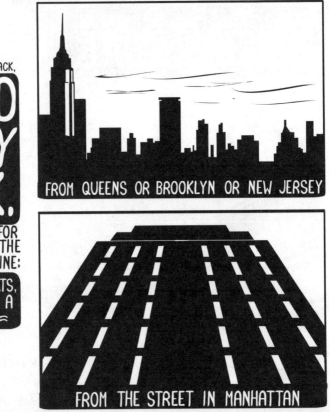

FROM QUEENS OR BROOKLYN OR NEW JERSEY

FROM THE STREET IN MANHATTAN

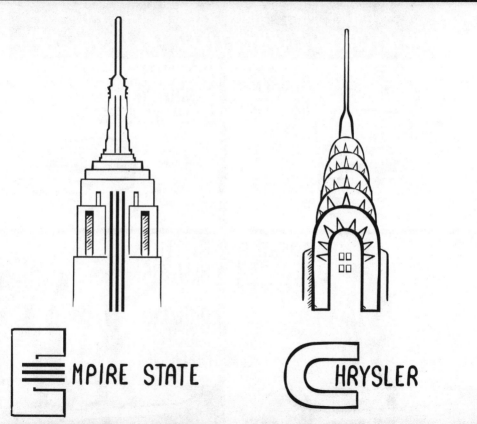

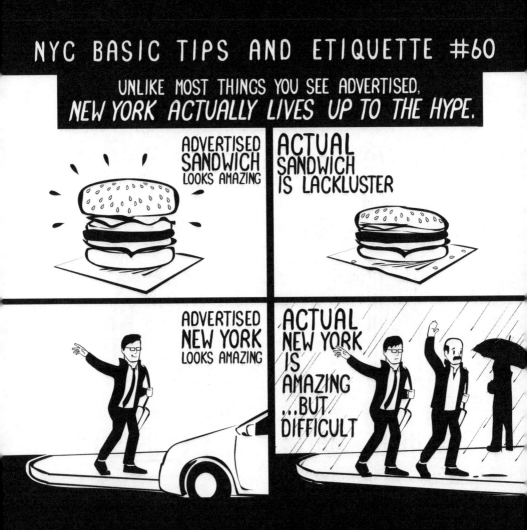

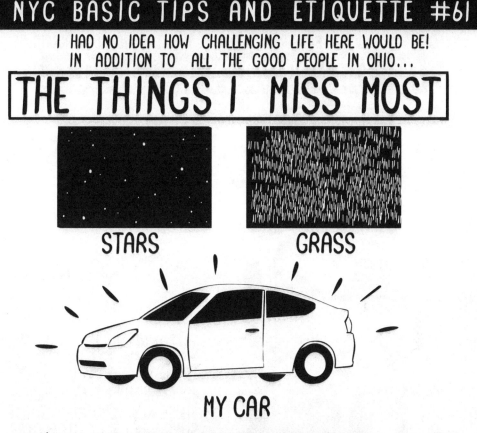

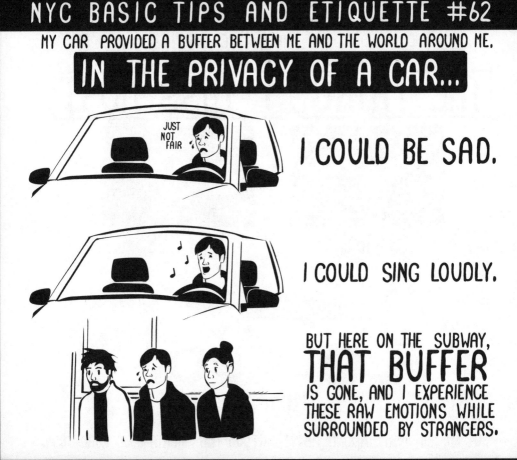

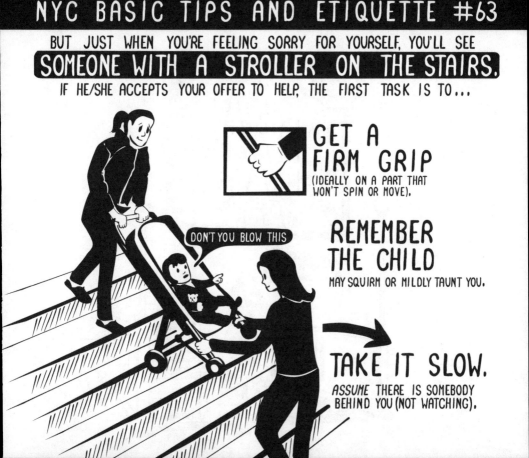

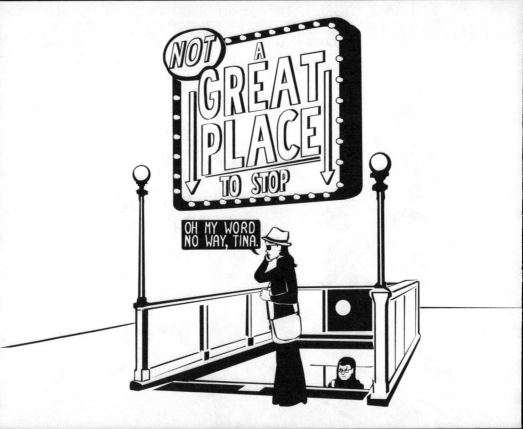

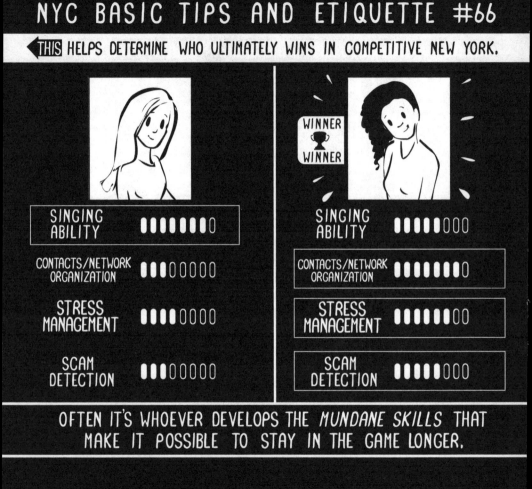

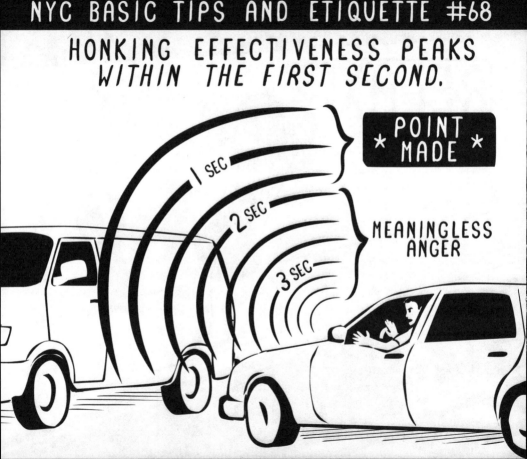

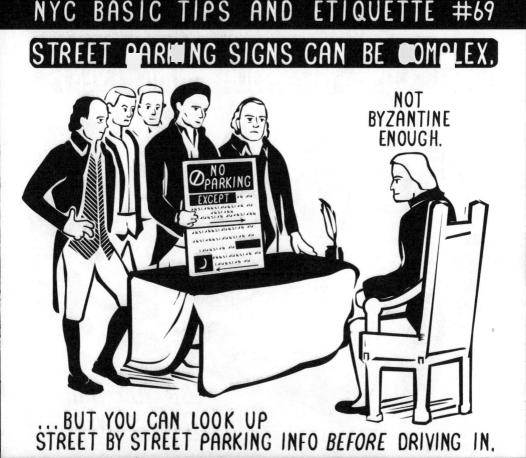

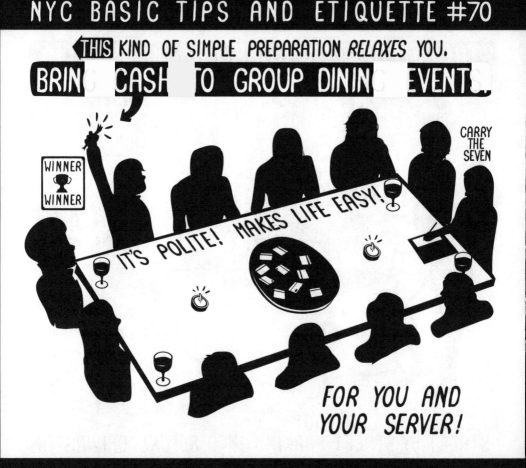

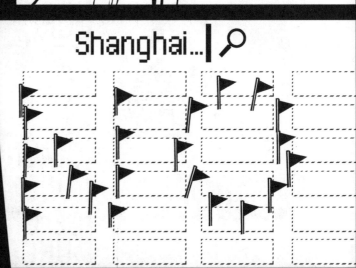

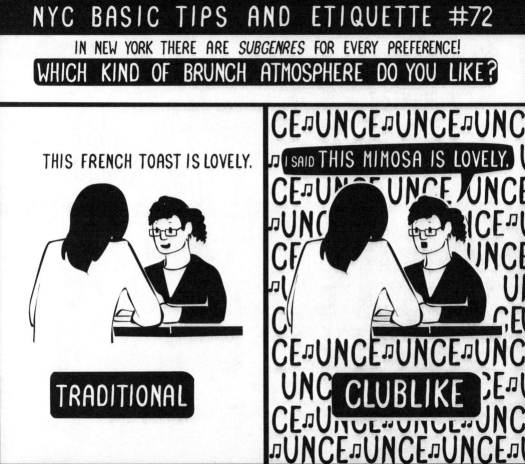

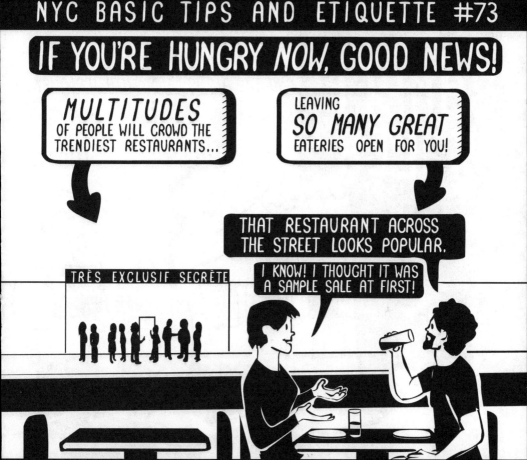

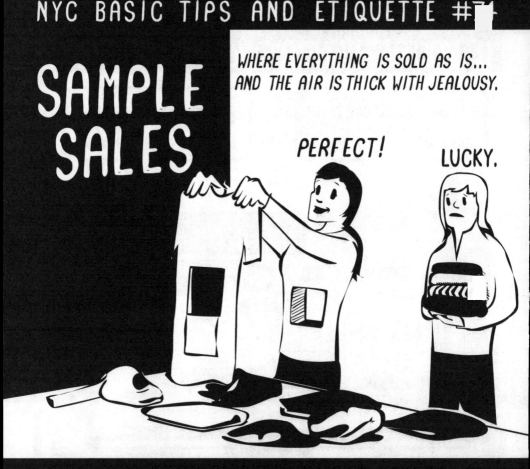

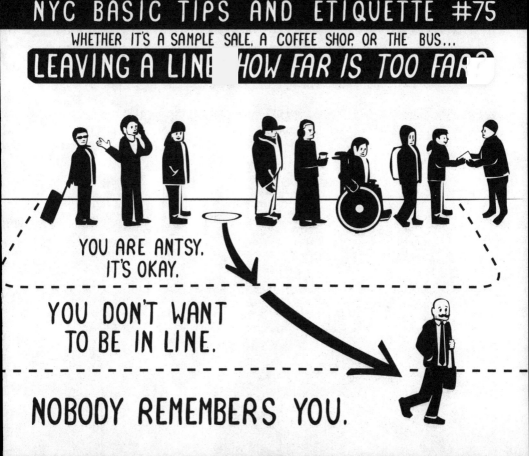

COMMON TOURIST PATH

COMMON TOURIST CONCLUSION:
*WE EXPLORED NEW YORK.**
IT IS SO CROWDED.
I COULD NEVER LIVE THERE.

*NO, YOU DIDN'T.

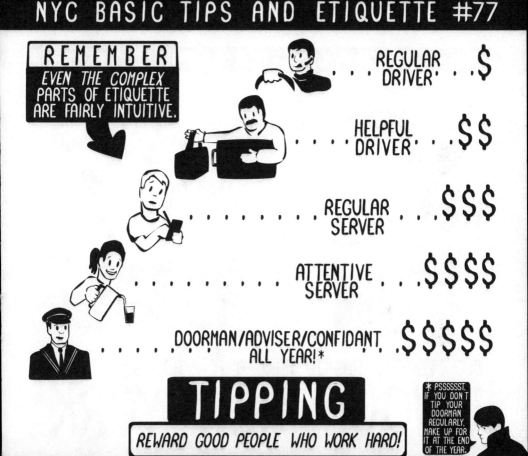

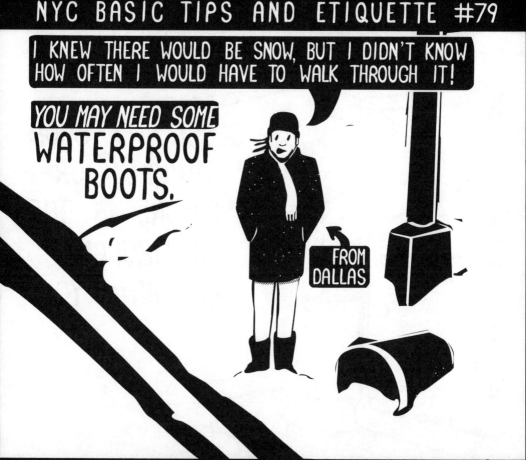

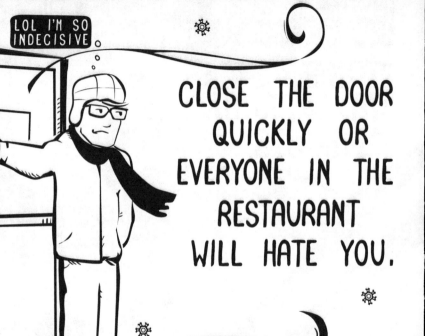

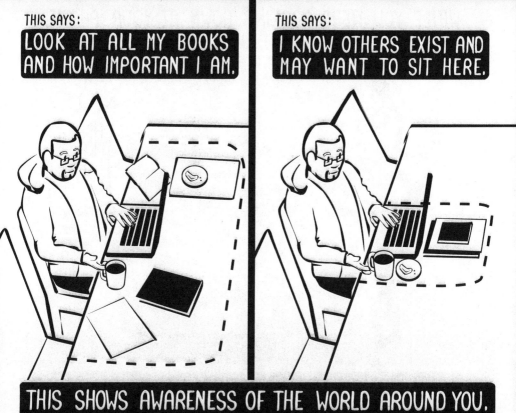

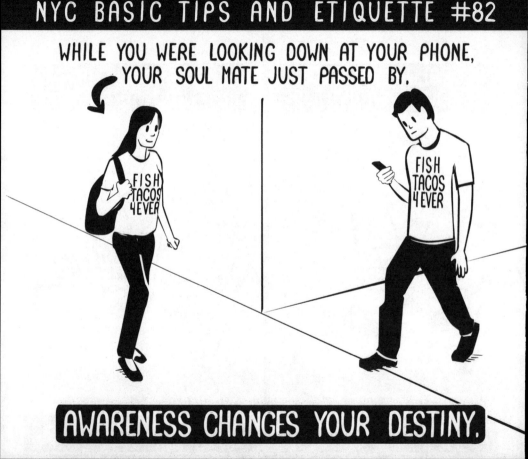

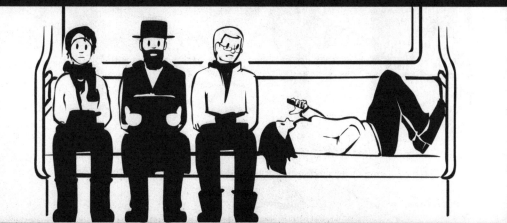

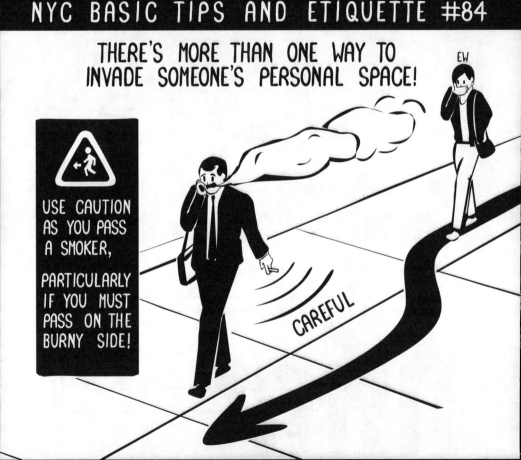

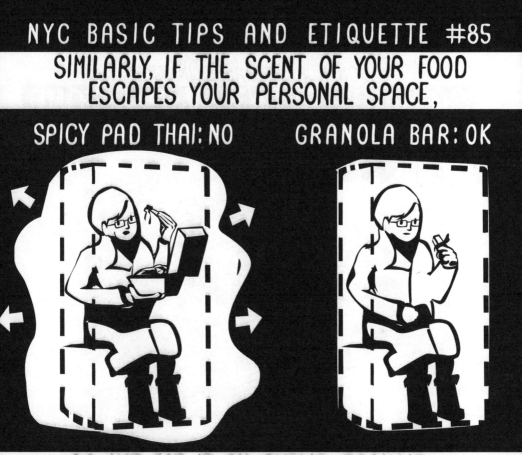

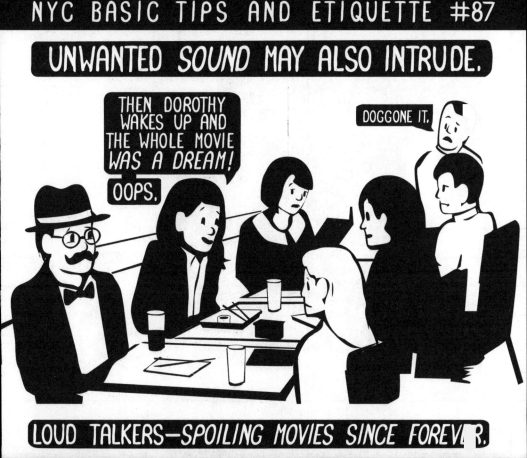

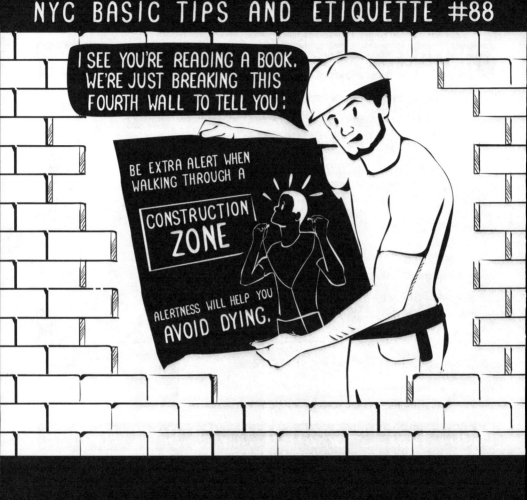

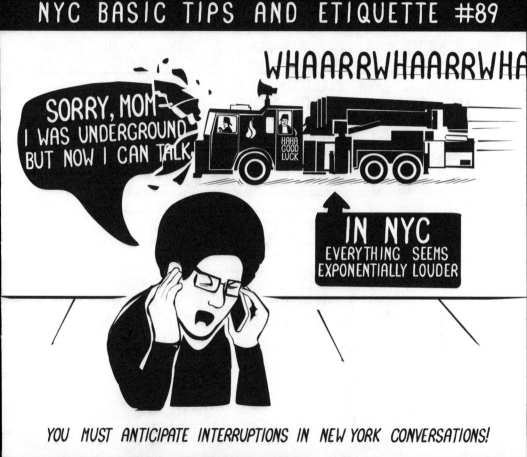

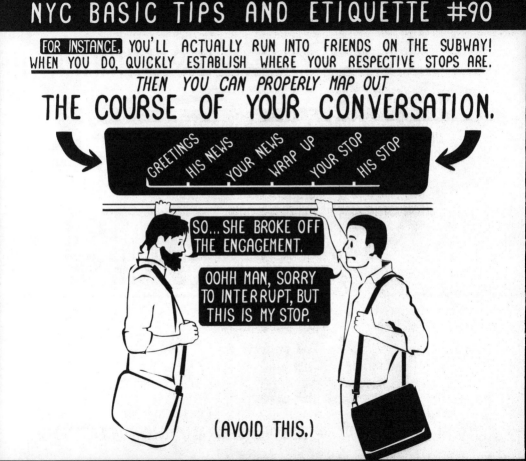

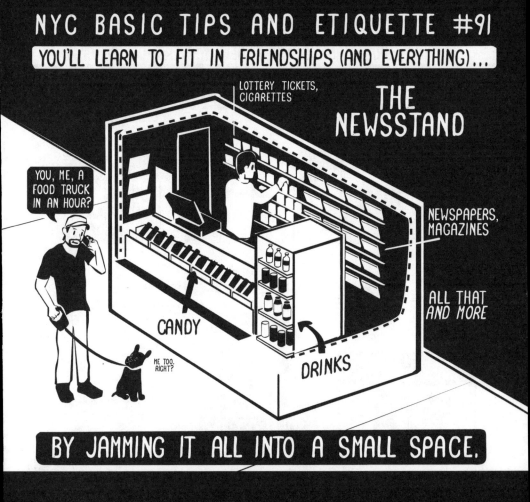

MINIATURIZATION IS WHAT NEW YORKERS DO BEST!

WHAT IS A BODEGA?

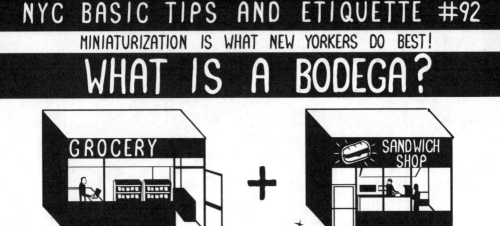

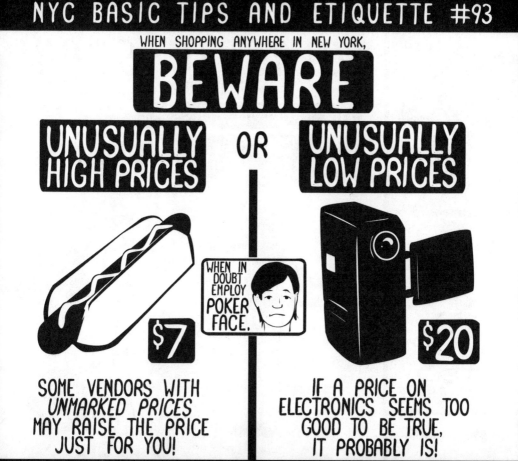

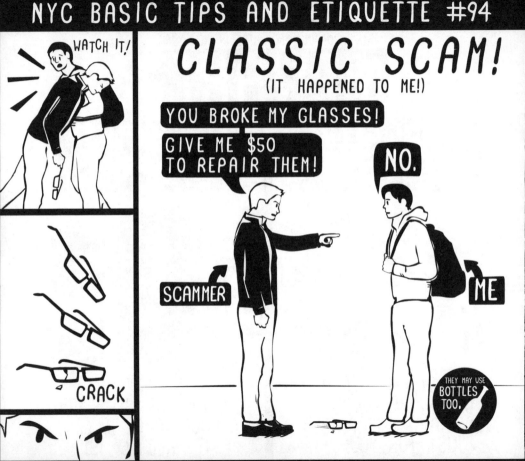

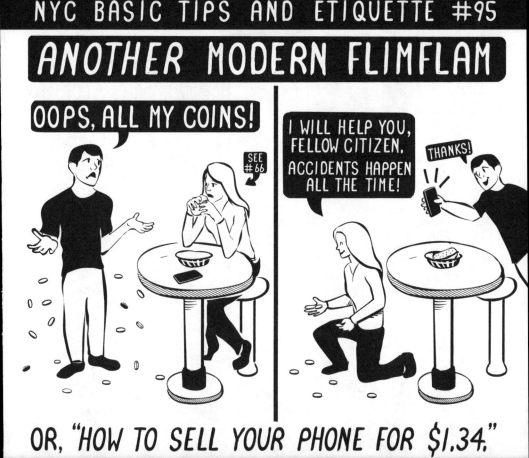

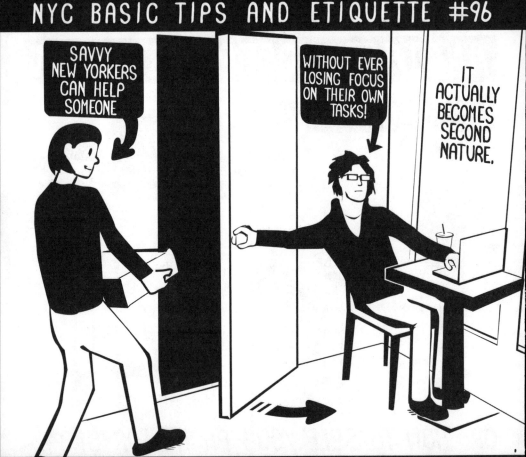

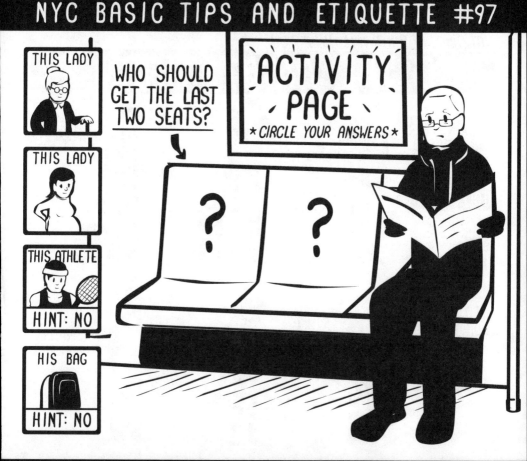

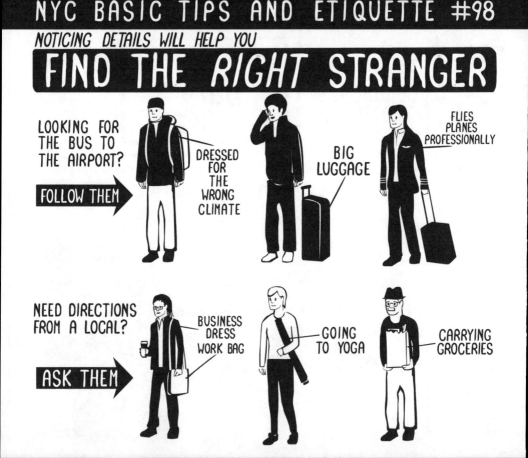

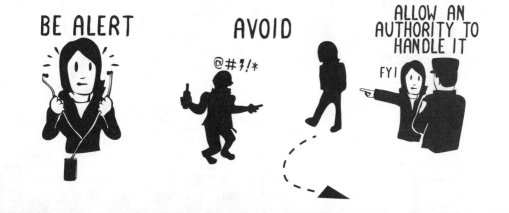

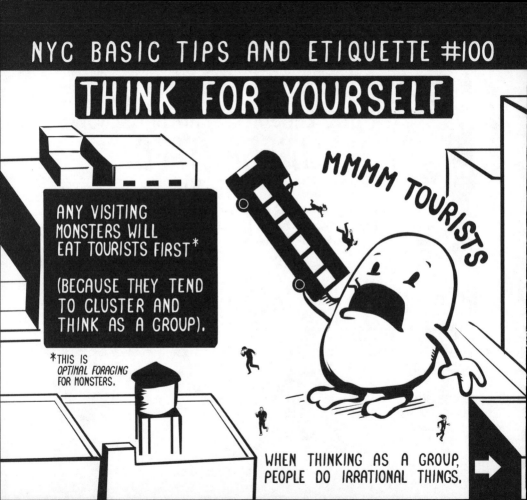

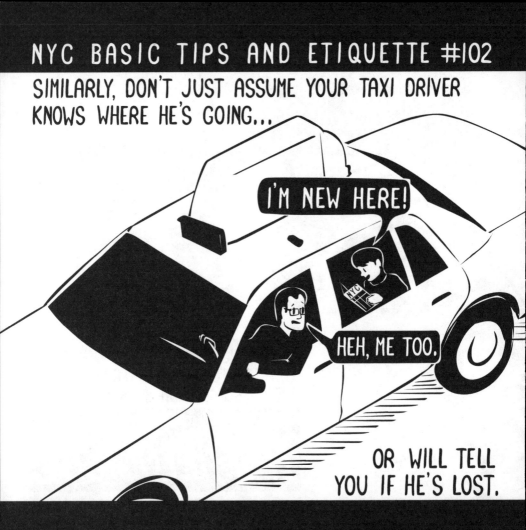

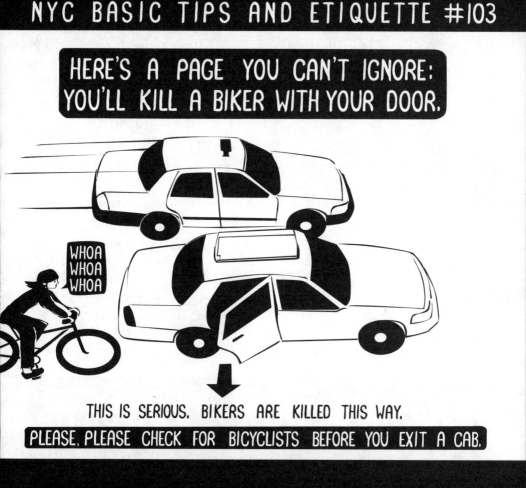

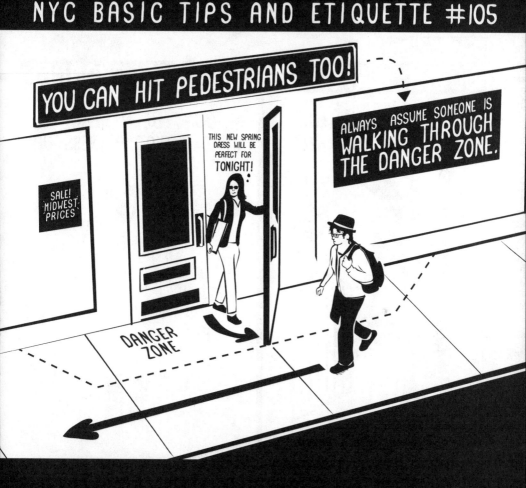

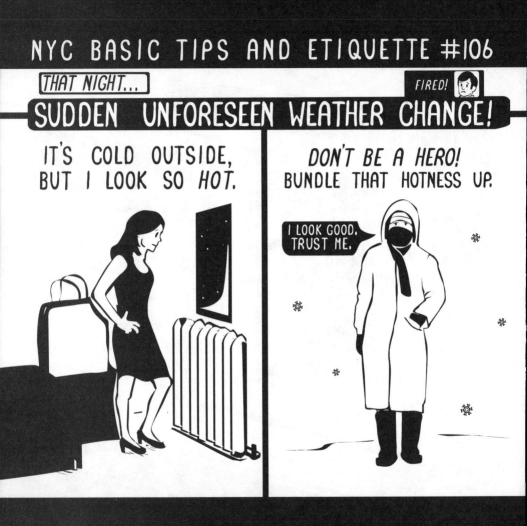

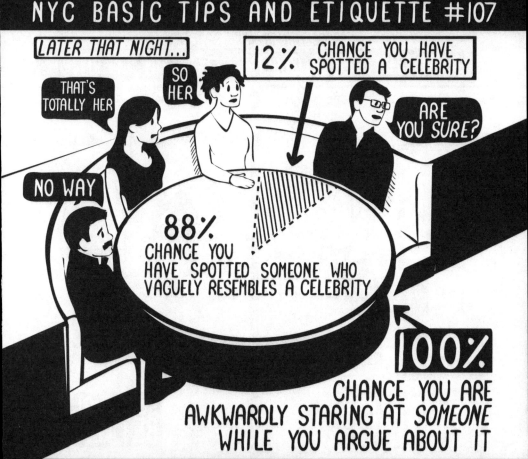

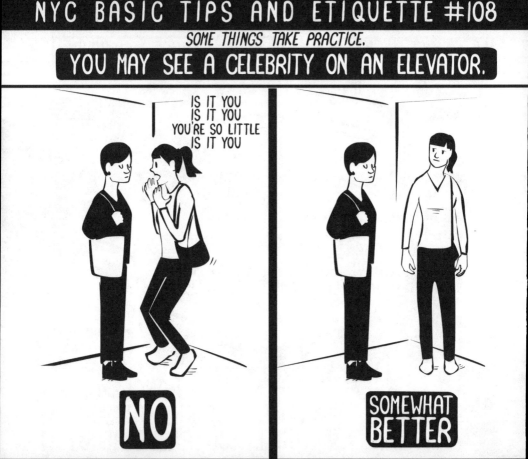

THE MOST BEAUTIFUL PERSON
YOU'LL EVER SEE WILL
BE ACROSS THE PLATFORM
ON AN EXPRESS TRAIN WHOSE
DOORS HAVE JUST CLOSED.

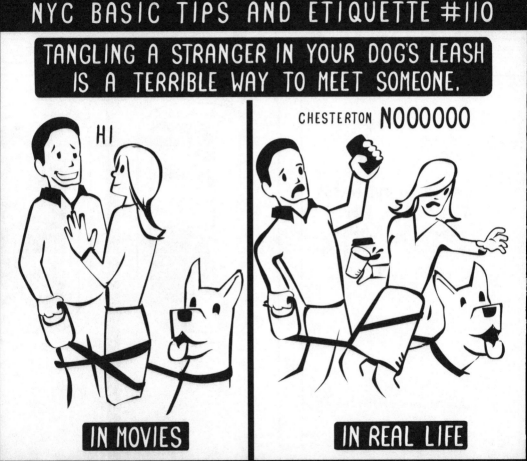

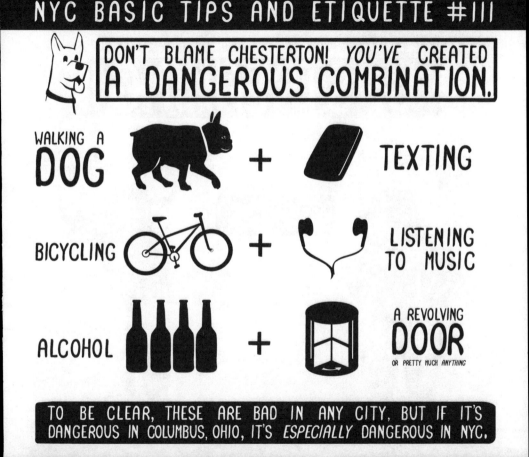

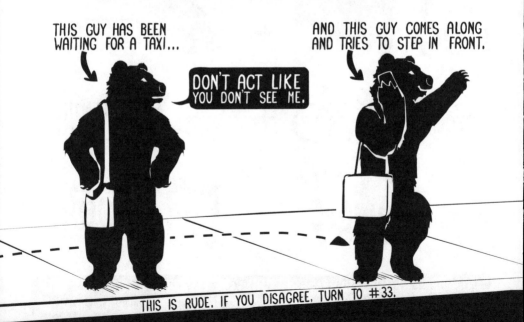

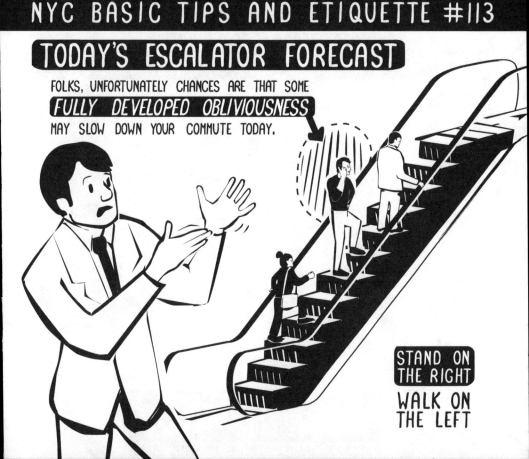

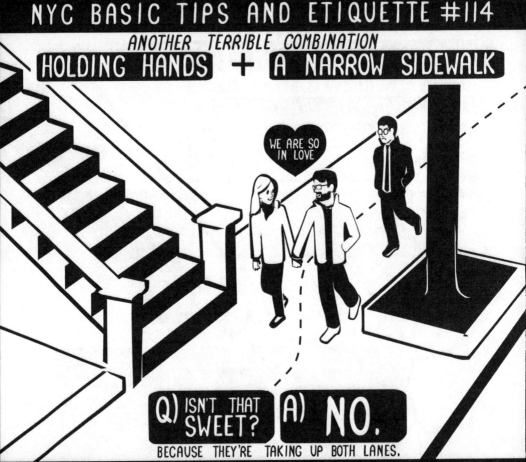

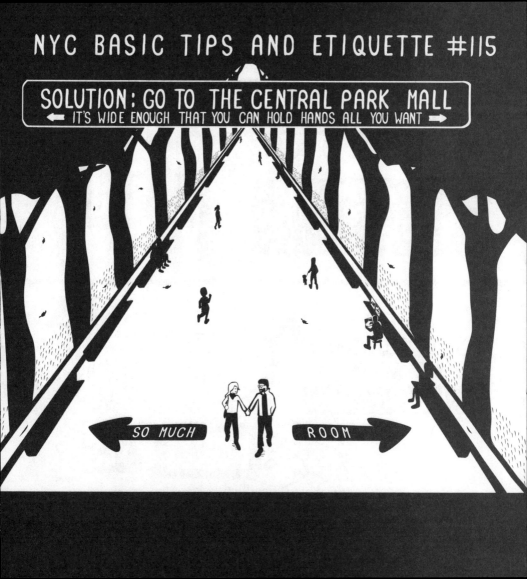

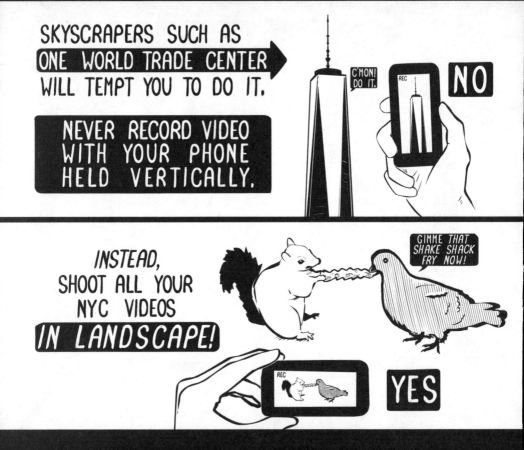

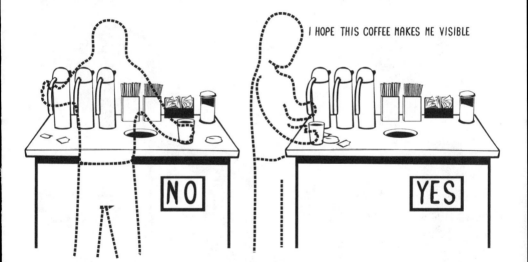

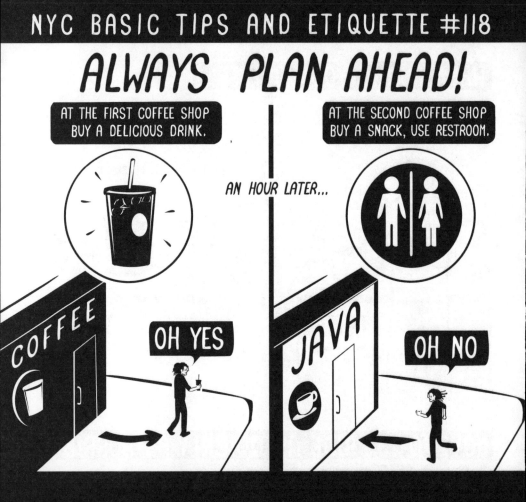

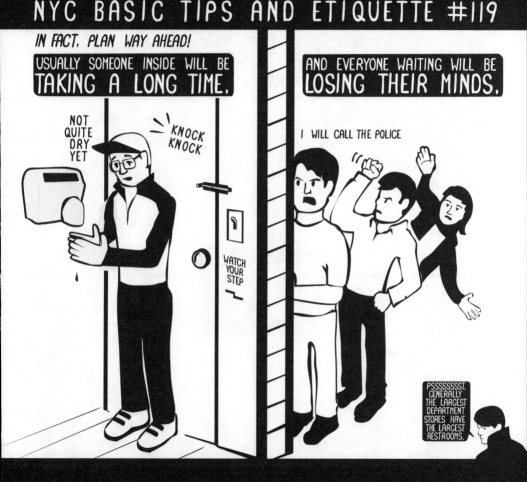

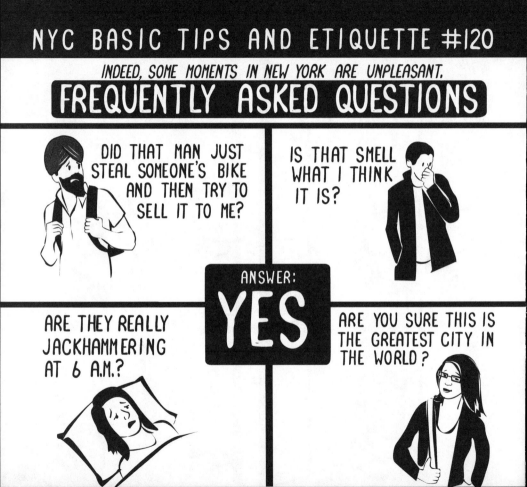

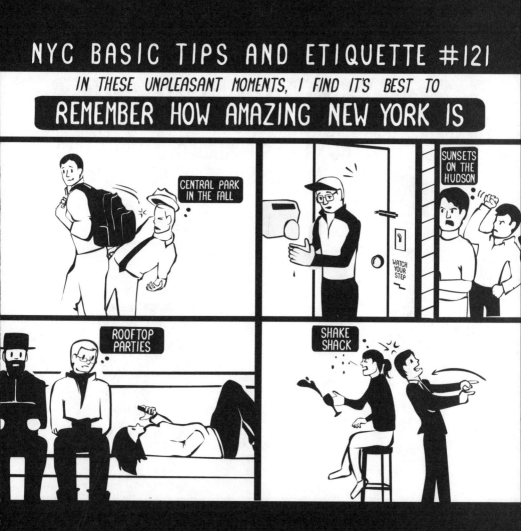

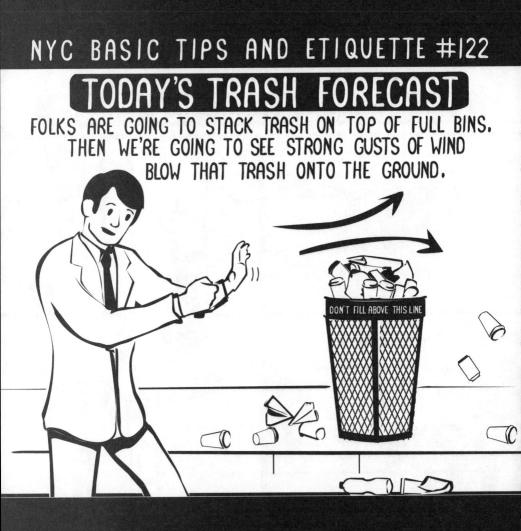

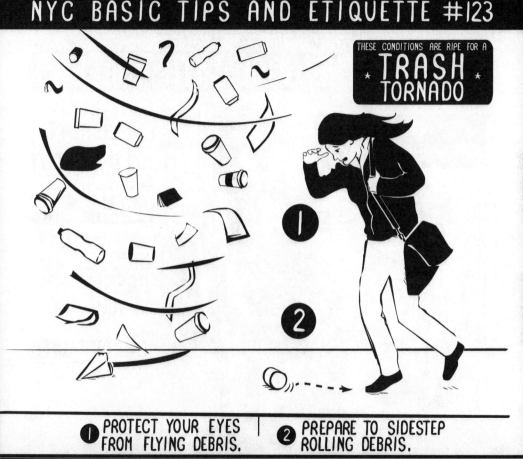

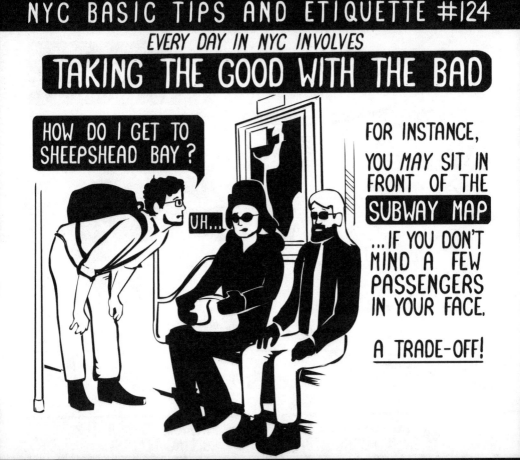

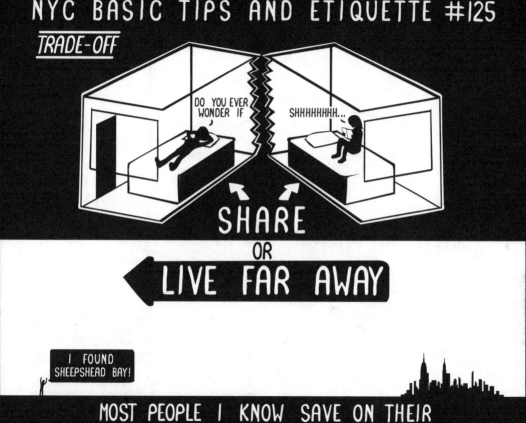

MOST PEOPLE I KNOW SAVE ON THEIR

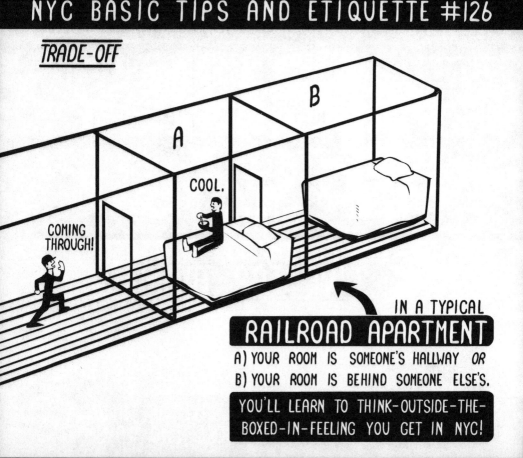

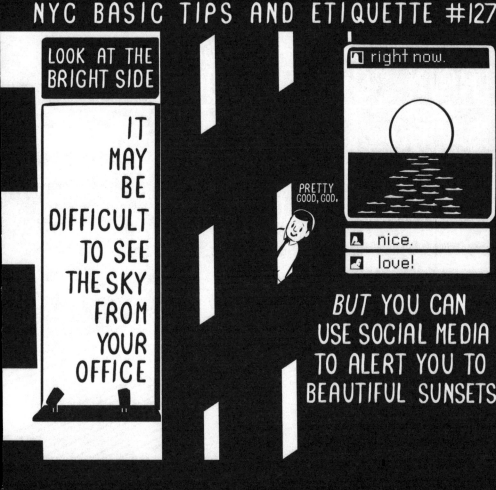

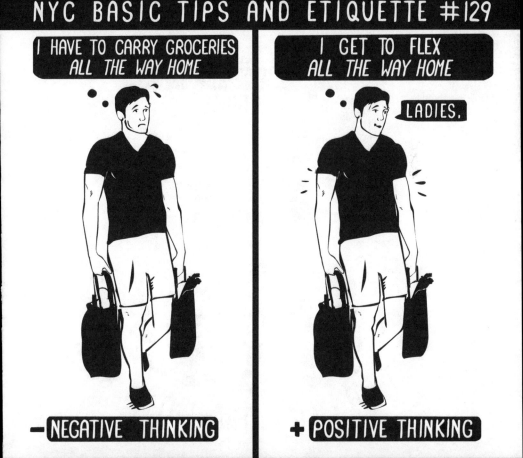

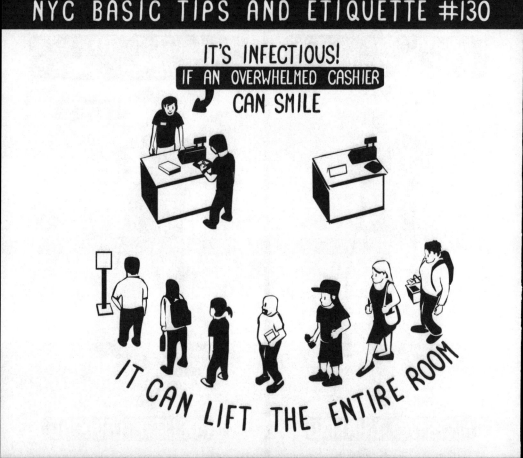

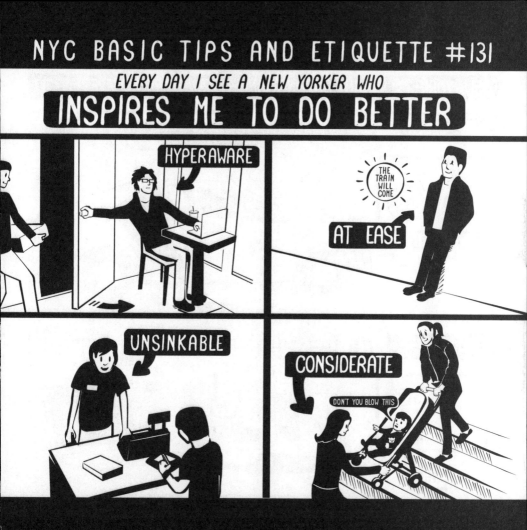

NYC BASIC TIPS AND ETIQUETTE #132

NEW YORK IS TOUGH AND NO ONE GETS IT RIGHT *EVERY DAY!*

LEVEL 1 — EXITS SAFELY!!

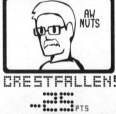

GOOD LOOKER!
+50 PTS

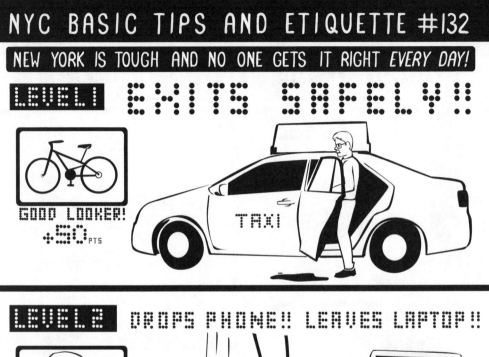

TAXI

LEVEL 2 — DROPS PHONE!! LEAVES LAPTOP!!

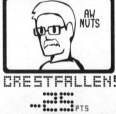

AW NUTS

CRESTFALLEN!
-25 PTS

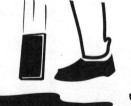

DAY IS RUINED

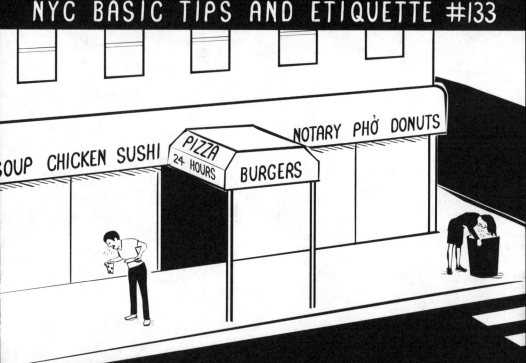

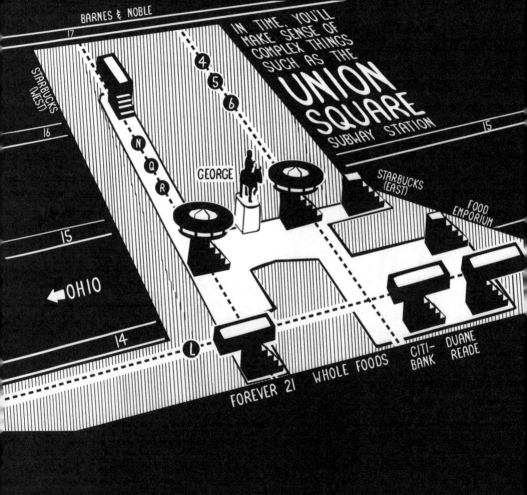

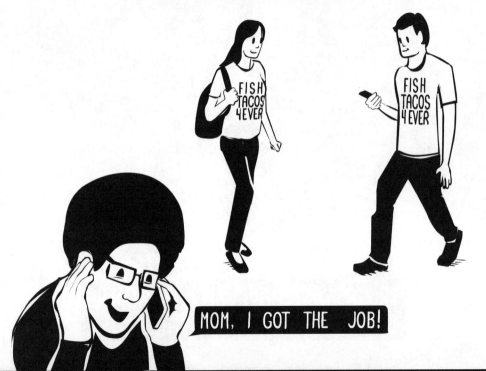